D0919052

An Introduction to Netsuke

BY THE SAME AUTHOR

The Netsuke Handbook of Ueda Reikichi
The Wonderful World of Netsuke
Collectors' Netsuke

RAYMOND BUSHELL

An Introduction to
NETSUKE

CHARLES E. TUTTLE COMPANY
Rutland, Vermont & Tokyo, Japan

Representatives
For Continental Europe,
BOXERBOOKS, INC., Zurich
For the British Isles,
PRENTICE-HALL INTERNATIONAL, INC., London
For Australasia,
PAUL FLESCH & CO., PTY. LTD., Melbourne
For Canada,
M. G. HURTIG LTD., Edmonton

WITHDRAWN

Published by the Charles E. Tuttle Company, Inc.
of Rutland, Vermont & Tokyo, Japan
with editorial offices at
Suido 1-chome, 2–6 Bunkyo-ku, Tokyo

Copyright in Japan, 1971
by Charles E. Tuttle Co., Inc.

Library of Congress Catalog Card No. 78–147176
International Standard Book No. 0–8048–0905–4

First printing, 1971

PRINTED IN JAPAN

Table of Contents

Note: All photographs were taken by the author. Netsuke are from the author's collection unless otherwise indicated.

Acknowledgments

"Ike" Ashida, though the busiest man I know, has shared my search for netsuke and related material for more than twenty years. Often it was his detection, perseverance, and tact that extracted important netsuke from their hiding places. The services of old friends, however, like those of close relatives, are sometimes accepted as due, and only mutely appreciated. This acknowledgment of my debt to Ike, though belated and inadequate, is something I feel deeply.

I am delighted to correspond about any aspect of netsuke. Letters may be addressed to me at the Sumitomo Building, Suite 832, Marunouchi, Chiyoda-ku, Tokyo.

RAYMOND BUSHELL

Introduction

What Are Netsuke?

The Japanese love of the miniature in art is well known—dwarf trees, tray landscapes, sword fittings, woodblock prints, and other diminutive arts. Miniature sculpture of figures, masks, dolls, and Buddhist images has played an important role in Japanese daily life since ancient times. During the Tokugawa and Meiji periods (1603–1912), miniature sculpture of a special type was born. It is called *netsuke*. There is no word for netsuke in the English language or in any other language, and so the Japanese word is in common use in all countries where netsuke are known or collected.

Netsuke are works of sculpture in wood, ivory, lacquer, porcelain, metal or other materials. They average about $1\frac{1}{2}$ inches in size, varying mainly between 1 and 3 inches though some of the older netsuke are often 4 inches or more in length. The netsuke was not intended to be used by itself. It was part of an ensemble; one member of a group. Its function was to suspend from the sash *(obi)* a hanging article *(sagemono),* such as a medicine case (Fig. 8), a tobacco

9

pouch, or a purse, by means of a cord. The netsuke as an article of utility is found in other countries, such as North China, Mongolia, and Hungary, where a loose outer garment is tied with a belt or sash. The sash makes a convenient hitching place for attaching handy articles. Only in Japan, however, did the netsuke develop from an article of utility into a sophisticated art object.

Today netsuke is a collector's item and is much sought after. But originally it was an article of utility, an object that performed a specific function. For some 300 years every well-dressed Japanese wore at the sash of his kimono a netsuke as an attachment to his purse, pouch, or lacquer box. It is the use of the netsuke as an article to be worn that distinguishes it from other miniature sculpture and from sculpture in general.

Sculpture in general is a free art form; the sculptor works under no restrictions or limitations. He may carve the side of a mountain with dynamite blasts and produce the profiles of four United States presidents, or he may carve a peachstone into a representation of Buddha and his 18 disciples. He may use any material, from clay to granite or jade. His masterpiece may be as streamlined and simplified as an egg or as jagged and complicated as an arrangement of metal tubes, coils, and angles.

The sculptor of netsuke, by contrast, creates and carves under rigid limitations imposed by the very use to be made of the object. The netsuke must be diminutive in size. It

must be sufficiently strong and sturdy to support the weight of the *inro*, pouch, or purse, and to withstand the rigors of daily wear. It must be designed so that the overall shape is smooth and rounded; no jutting parts or appendages are permitted that might break off or tear a kimono sleeve. As the netsuke is expected to be handled and admired and to be turned this way and that, it must be finished on all sides, including the bottom. Lastly, a cord must be attached to the netsuke, usually through holes. The holes must be drilled so that they do not mar the design, and they must be placed so that the netsuke hangs naturally and with the face or best side visible. Creativity is difficult and rare in free sculpture. How remarkable then is the original and artistic netsuke when we remember that it was created despite frustrating restrictions!

Fortunately there is another side to the coin. The netsuke artist enjoyed one priceless advantage that more than balanced the onerous requirements in carving a proper netsuke. He was completely free of any external restraints. His was a popular art. The choice of subject, material, design, and style was entirely his to make. He had only himself to satisfy and his patron to please. Unlike the academic and court artists he had no royal stipend or sponsorship to lose, no supervisors to satisfy, and no school or artistic tradition to conform to. He might live in poverty as compared to the painter, sculptor, or lacquerer who was provided for by a *daimyo,* but he was free to carve anything that caught

his fancy and to carve it in any way that pleased his artistic soul.

In its shadowy beginnings the netsuke served as an article of utility; but the Japanese artistic genius does not permit objects of common use to go unimproved. The original netsuke was no more than a shell, a gourd, a stone (Fig. 6), a bit of wood (Fig. 9) or bamboo, or some other natural object. Probably the first striving towards an artistic improvement was the discriminating selection of natural objects in particularly attractive or interesting shapes, with a minimum amount of smoothing, shaping, and polishing to enhance the natural appeal. The netsuke progressed through stages of shaping, carving, and decorating into an object of show and vanity, much as the jeweled ring of today or the fancy cane of yesterday. Every technique of the sculptor's craft was employed, from relief, high, low, etched, or sunken, to full round figures and groups; and every style, from microscopic ornateness to monumental simplicity. Most fine netsuke are carved from solid blocks of choice material, and some are enhanced by the addition of color or inlay.

There are few more pleasant ways of becoming acquainted with the Japanese than through an examination of a comprehensive netsuke collection. They reveal a great deal of Japanese life that is not found in the history books. Netsuke was a popular art, and the subject matter was unlimited. History and legend; gods and saints; ghosts and

goblins; animals, real and fanciful; people of all stations, callings, and conditions; habits and customs, quaint, surprising, and lusty; activities, innocent, spiritual, earthy, and naughty—all are the domain of the irrepressible netsuke artist.

Less than half of all netsuke are signed. The early ones are usually not signed. Our knowledge of the individual artists is very scanty, and almost nothing is known of the various carving schools. Source, provenance, and pedigree hardly exist—except for the records of a few European collections dating from this century. Therein, paradoxically, lies one of the great charms of netsuke as an art form. Our delight and appreciation tend to spring from their intrinsic artistic merit rather than from less valid considerations of signature, artist, school, attribution, provenance, and pedigree.

One of the most appealing qualities of a netsuke is a quality that, amazingly, was not carved into it by the artist who created it. It is the smoothness and luster brought about by generations of loving handling and wearing. It is the owner's contribution to the netsuke. The Japanese call this quality *aji*. A netsuke without *aji* is somehow incomplete.

Netsuke are no longer in common use—the introduction of Western dress contributed to their demise—but they are more alive today than ever before. They are established throughout the world as collectors' items, prized examples of the fine art of miniature sculpture.

Origin and Development

The historical origins of netsuke are as shadowy and un-
certain as the supernumerary buttons on men's jackets. This
much is certain, however: the netsuke as a basic article of
utility developed in those countries where the national dress
is a loose cloak or sack tied with a belt or sash and in which
no provision is made for pockets. This is the case for example
in Hungary, Mongolia, and Japan. The practice developed
in these countries of tying handy articles to the sash where
they are conveniently out of the way yet quickly available
for use. It is safe to say it is the absence of pockets in the
national dress and the necessity of carrying objects of daily
use conveniently that mothered the invention of the netsuke.
The netsuke as an article of utility served as a counterweight
or toggle to prevent the hanging object from slipping
through the belt or sash, whether a hunting knife in Hun-
gary, a tinder box in Mongolia, or a tobacco pouch in Japan.

The earliest recorded history of Japan, the *Kojiki,* com-
pleted in the 8th century, mentions the use of a bag for
flint and tinder attached to a sword hilt. During the periods
that followed many chronicles mention and many paintings
depict the carrying of bags, purses, gourds, keys, and tinder
boxes attached to the sash by an ivory ring or a basic netsuke.
(I use the term basic netsuke to indicate an article of utility
only.) It performs the function admirably of supporting one
of the group of hanging objects mentioned above. How-

ever, the basic netsuke was neither shaped, carved, nor decorated. It is in this way distinguished from the first netsuke that were treated artistically. The artistic netsuke probably did not appear until the end of the 16th century.

What were the prototype netsuke like, the basic netsuke that preceded the artistic netsuke? They were gourds, shells, wood, bamboo, or other natural products that could serve as a counterweight and as a place of attachment of the bag, tinder box, purse, or other hanging object. There is good evidence that small natural gourds served as netsuke from the fact that when artistic netsuke first appear they are often worn together with a natural gourd netsuke. As usual, old customs die slowly.

Probably the first striving towards an artistic netsuke was the discriminating selection of natural stones, shells, and roots with interesting shapes and forms. Enhancements by polishing or a minimum amount of shaping were sometimes added. The technique of binding in order to force the growing gourd into a predetermined unique shape is well known in Japan. Nevertheless, interesting natural shapes, polishing, and minor modifications seldom add up to a collector's netsuke.

There are references in Japanese records to lacquer *inro* in use in the final quarter of the 16th century. The *inro* is a compartmented lacquer box, suspended by netsuke. We know that lacquer artists such as Koetsu Honami produced fine *inro* in exquisite taste during the late 16th

and early 17th centuries. Since the *inro* must be used *en suite* with a netsuke, the mere existence of the *inro* presupposes the netsuke. The same lacquerer who made the *inro* would frequently make the netsuke also, in style, color, or subject complementing the *inro* (Fig. 8). The first artistic netsuke then were lacquer netsuke, the work of lacquer artists, and they were prevailingly in the *manju* or box-and-cover shape. Why then are there so few lacquer netsuke extant that may reasonably be attributed to the 16th century? The answer may be that few were made to begin with. Strict custom, if not sumptuary laws, reserved the *inro* to the samurai class. And even among the samurai it does not appear that the custom of carrying an *inro* was universal at this initial stage of development.

The great impetus to the development of the netsuke was the spread of tobacco and smoking at the beginning of the 17th century. The strength of the smoking habit may be judged from the fact that the second Tokugawa shogun prohibited the cultivation and sale of tobacco, and that the edict was evaded so prevalently that it became a dead letter. Loose tobacco was carried in a pouch hung by means of a netsuke from the sash. The tobacco was smoked in a long-stemmed pipe *(kiseru)* ending with a tiny bowl smaller than a thimble, barely enough for three whiffs. In contrast with the *inro,* which was limited to the samurai, the tobacco pouch, whether wood, leather, or brocade, was universally carried by farmers, fishermen, artisans, and merchants.

The three centuries of the Tokugawa, Meiji and Taisho eras (1603–1925) witnessed the birth, growth, peak, and demise of the netsuke. During these eras styles in netsuke underwent substantial changes temporally, regionally, and socially. In Japan as in other countries, styles come and go and everyone tries to conform to the latest vogue. The netsuke had to adjust to constantly changing styles in bags, pouches, purses, and pipe cases. Some changes were mere modifications, others quite radical innovations. The large heavy netsuke that suspended a wooden tobacco pouch (*tonkotsu*) or a metal pipe and pipe case (*tsutsu*) was suitable for the farmer, but the merchant who carried a brocade tobacco pouch required a light elegant netsuke. To trace in particularity the changing styles in netsuke from period to period, from region to region, and from class to class should prove a fruitful field of research. Fortunately the main variations of the netsuke are quite well known.

The earliest artistic netsuke of universal use—not the lacquer netsuke of the samurai class mentioned above— were large netsuke showing strong Chinese influences (Fig. 1). They are the netsuke of the 17th and 18th centuries produced mainly in the Osaka-Kyoto Area (Kansai). They are the netsuke illustrated in the *Soken Kisho,* 1781, the first book in any language treating of netsuke. What are the characteristics of these early netsuke? They are large in size, as much as 5 or 6 inches in height and sometimes quite massive. The subject matter is frequently the fables

and legends of China, the fantasy of Taoist belief, and the Chinese lion *(karashishi)*. The material is ivory or wood and occasionally horn. The carving style is Chinese. The figures are almost always in the standing position and tend to be simply but powerfully rendered. In conformity with the practice of the Chinese carvers the early netsuke usually bear no signature or identifying mark. To appreciate the intensity of the Chinese influence on the earliest netsuke we must understand the tide of Chinese scholarship, literature, history, art, and art objects that swept the country prior to the Tokugawa era.

A second distinct style of netsuke predominated in the Nagoya-Gifu-Ise area during the 18th and 19th centuries. The main characteristics of this style are animal subjects, wood media (especially boxwood), a size of $1\frac{1}{2}$ or 2 inches, simplicity of treatment and a well-rounded form usually bearing the signature of the artist (Fig. 10). These excellent qualities often add up to the perfect netsuke in subject, size, shape, and design. In the Osaka-Kyoto area of an earlier age the Chinese influence was very pronounced. In the Nagoya-Gifu-Ise area the predominant influence is a love of nature and its seasonal variations, of delicacy of sentiment, and of subtle allusion. This influence was fostered by the great poets of the period, like Basho, whose subtle lines evoked the most fleeting emotions and an acute awareness of nature in a flower petal or in the beat of a bird wing.

A third great style originated in the Tokyo area princi-

pally during the 19th and 20th centuries. Remembering that artists from all over the country sought fame and fortune in the sprawling capital, it is not surprising that the Tokyo style is less subject to precise definition than either of the two main styles previously described. Tokyo carvers, independent and proud of being sons of Tokyo *(Edokko),* took distinctly Japanese—if not Tokyo—activities for their subject matter (Fig. 7, 11). Like the ukiyoe creators, the netsuke artists were concerned with the life, occupations and pleasures of the ordinary people about them. The Tokyo carver typically portrayed the stonecutter, the storyteller, the tippler, the musician, the masseur, and so on. The Chinese hero of Osaka and the startled deer of Nagoya were not often subjects for the Tokyo artist. He found his next-door neighbor or the corner theater closer to his bone and blood. The cartoons and drawings of Hokusai and other artists and the ukiyoe prints were all the inspiration and model the Tokyo netsuke artist needed.

The golden age of netsuke covered the first half of the 19th century. The tobacco pouch was at the height of its vogue and many fine sculptors devoted themselves exclusively to the carving of netsuke. So great was the demand that potters, lacquerers (Fig. 21), metal artists (Fig. 18), and mask carvers produced netsuke as adjuncts to their main professions. Rare woods and unusual materials were imported from the South Seas and the Asian mainland to satisfy the elegant tastes of the newly rich merchant class.

Various influences contributed to the demise of the netsuke. However, it was not a sudden death. Numerous sales catalogues of the 1920's and 1930's carry illustrations of rich tobacco pouches and fine netsuke sold in the galleries of Tokyo and Osaka. Kyusai, Gyokuso, and Soko, among others, were still carving netsuke in the 1920's and 1930's to fill the special orders of wealthy customers and dealers.

The toll was sounded by changing customs, especially the popularity of cigarettes over loose tobacco and the adoption of Western dress. The netsuke no longer had a function to perform and it gradually declined. Today it is entirely in disuse except by a few old farmers and, strangely enough, the geisha. These little ladies sport gaily-colored lacquer *inros* with matching *manju* netsuke almost as a symbol of their attachment to the old Japan, a symbol of their protest against the decline of the teahouse before the onslaught of the golf course.

Materials of Netsuke

Frequently the question is asked: Is it genuine ivory? The answer depends on definition. If ivory is defined as the tusk of the elephant, then ivory from other sources will be classed as imitation or substitute ivory. If ivory is defined as animal tooth that outgrew its basic function of chewing and developed into a formidable weapon of attack, then we must include the tusk of the walrus, the tusk of the narwhal,

and the tooth of some whales. These other ivories are collectively referred to as marine ivories or, popularly, fish ivories.

Elephant ivory is distinguished in cross section by a perfect geometric pattern of intersecting circles. The pattern will usually show at some part of the netsuke. Narwhal is identified by spiral grooving along the bark of the tusk (Fig. 14). Walrus has a brainlike, cellular or granulated mass running through the central portion of the tusk. Whale tooth is unmarked except for occasional tiny spots of dentine that sometimes blemish the tooth. There is also a color separation of the cement and dentine areas.

The great advantage of elephant ivory is its large size and very tiny nerve core. Correspondingly, the disadvantage of narwhal, walrus, and whale tooth is their large central hollow core. However, given adequate size, the marine ivories are not inferior. In fact marine ivories often show a specially lovely translucency. The defects to be on guard against in the marine ivories are the unsightly patches sometimes inserted to cover the hollow core.

Another basic question is frequently asked: Is it good ivory? The best ivory is prime live ivory of medium hardness and size. By prime live ivory is meant the tusk of an elephant in its youth or prime taken while the animal is alive or just after it has died. The ivory is then moist and lustrous, with a smooth texture. It is neither clayey nor crumbly, and it is very responsive to the carver's knife. The

middle third of the tusk is the best part. The Japanese carvers call the choicest elephant tusk *tokata,* which they say is found only in the elephants of Thailand and Cambodia. The huge tusks of aged bull elephants do not furnish good ivory. The material is often dry, hard, crumbly, and lusterless.

The collector need not burden himself with concern about the age, condition, or species of the animal that produced the ivory from which his netsuke are carved. Ivory quality can generally be clearly seen in the luster, texture, and color of the netsuke. A carving of pleasing color, smoothness, and luster indicates ivory of superior quality. Conversely, dry, dull, scarred, or pitted ivory indicates poor quality. A corollary is to regard with suspicion any netsuke so heavily painted, tinted, or stained that the the surface of the material is not visible. Occasionally bad cracks in poor netsuke are filled with lacquer and the surface is then thickly stained to conceal the repairs and imperfections.

Much is made by many collectors of the superiority of wood over ivory. There are many opinions among collectors pro and con. Ivory is certainly more durable and somewhat more precious. At its best, ivory is only slightly, if at all, less sensitive than wood. Wood has more variety in color, texture, and grain. At the outset of netsuke carving, wood was certainly the material with which the Japanese carver was more at home and experienced. Later, particularly during the Meiji period, the carvers were saying

ironically that "if it isn't ivory it isn't sculpture." A great advantage of wood is the pleasure of an abstract design in the grain of the wood in addition to the carving itself. In my opinion material is important only to the extent that the artist selects the material most appropriate to the particular subject and design. The greater sensitivity of wood is no advantage in a design that does not require delicate carving. The ideal is a perfect marriage of material with design.

Staghorn is one of the most prevalent materials found in netsuke. Staghorn is easily identified (Fig. 15). It is the antler of the native Japanese deer popularly known as the Nara deer. It is a bonelike material with a hard outer shell and a dark spongy marrow. The bark of the antler has a characteristic corrugated surface.

Staghorn is generally regarded as an inferior material, but the reputation is undeserved. Once the spongy part is scraped away staghorn is harder and more resistant to wear than ivory. Some of our finest netsuke are staghorn. However there are cautions to be observed in examining staghorn. Often the hollow or porous part of the antler is capped, plugged or patched. Often the design is dictated not by artistic considerations but by the branchlike configuration of the material. These are the misshapen carvings that can only be described as cripples.

Wood, ivory, and staghorn account for the vast majority of netsuke, possibly 80 to 85 per cent. Nevertheless, because

of their rarity some of the other materials are extremely desirable. One of the rarest of all is hornbill ivory (Fig. 16). Obtained from the casque surmounting the hornbill's huge bill, it is billiant orange-red and yellow in color. Carvings from the horn of the ordinary ox or water buffalo are very scarce, and netsuke of rhinoceros horn are extremely rare (Fig. 17). Boar tusk netsuke are not only rare but are especially prized when they are the product of the famous carvers of Iwami (in the present Shimane prefecture), such Tomiharu, as Bunshojo, and Kamman, who rather frequently carved netsuke from the tusk of the wild boar (Fig. 20).

Coral netsuke are scarce and are usually the product of carvers of the Meiji-Taisho periods. As products of the Tokugawa period, they are even more scarce. White coral netsuke are much rarer than red or pink coral. It is unusual to find a carved white coral netsuke. Usually white coral is only shaped, its rarity as material being considered a sufficient *raison d'être*. This is also the case with malachite, lapis lazuli, and jade. The material alone justifies the netsuke and therefore these hardstones usually are shaped and polished but not carved. Mother-of-pearl netsuke are occasionally found, but often they are crudely carved on one side only. A mother-of-pearl netsuke beautifully carved on both sides is a rarity.

Tortoise shell is another scarce material. Its origin is usually obvious from the shape of the netsuke. Due to its

thinness it is almost always carved in relief. Tortoise shell of sufficient thickness to be carved in the round is very rare. Despite the natural beauty of the material, amber netsuke are usually crudely carved if carved at all. Otherwise they are simply amber boulders nicely shaped, polished, and mounted with metal attachments. A finely carved amber netsuke is a rarity. Black coral or seapine *(umimatsu)* is difficult to find in a perfect dense chunk of sufficient size for a netsuke, and when found it is difficult to carve minutely because it is prone to split or chip. Hence fine netsuke in *umimatsu* are rather scarce. Walnuts of a special large size from the Sendai area and vegetable ivory, sometimes called ivory nut (Fig. 19), are generally poorly carved. Occasionally, however, one is able to find superior carvings in these materials.

Among the rarest materials I know are an iron dragon holding a genuine diamond in its claw, and a natural pearl in the shape Mt. Fuji, which is illustrated in *The Wonderful World of Netsuke*.

The question is sometimes asked about the existence of solid gold netsuke. Of course they do exist in the *kagami-buta* form of a solid gold lid set in an ivory bowl, but I have yet to see a gold netsuke of certain authenticity carved in the round. Traditionally the attitude of the Japanese metal artists is that gold should speak for itself and not be embellished with carving unless inconspicuous, as in the case of a slide bead *(ojime)* or hilt ornament *(menuki)*. Even

so, the metal artist often covered the solid-gold foundation of the *menuki* with designs in base metal overlays.

It should not be thought that this discussion about materials is complete. However, a more detailed examination of materials and other fascinating aspects of netsuke is outside the scope of this brief introduction.

The Plates

◈ DUTCHMAN

PL. 1. The subject of this very large netsuke is a Dutchman holding a man-child. The curly hair, beard, and large nose of the foreigner is emphasized. The weirdness is augmented by the child, which is less a baby than a miniature replica of the father.

> Material: Ivory
> Height: 10.2 cm (4″)
> Unsigned
> Date: 17th or early 18th century

From the collection of Mrs. Sammy Lee, Tokyo. Mrs. Lee is the wife of a prominent Chinese antique and rug dealer. She has 100 choice netsuke, most of which are ivory animals.

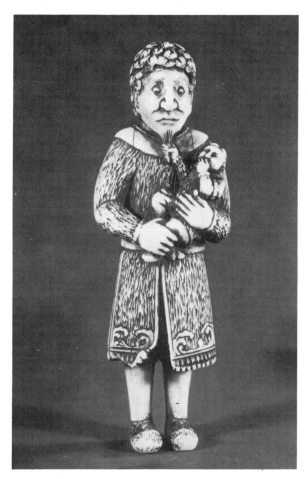

I

◆ SENNIN

PL. 2. The subject of this very small netsuke is a *sennin,* a member of a group of holy men of Taoist legend who live to a great age but remain always youthful and happy. The carving is in imitation of the style of Yoshimura Shuzan, the great name on the roster of netsuke carvers. Shuzan subjects are frequently *sennin* in colored wood as in the illustration, but many times larger.

> Material: Wood, colored in subdued tones
> Height: 3.5 cm. $(1\frac{2}{5}'')$
> Signed: Tetsugen
> Date: Late 19th century

Tetsugen is the art name of Hirai Shin, who was born in Osaka in 1879. After Tetsugen reached the age of 36 (1915), he changed his art name to Kyusai. Tetsugen won a prize for carving at the Paris International Exhibit of 1895 at the age of 16. In Japan he is considered one of the great artists of the Meiji-Taisho periods (1868–1925).

From the collection of Mr. Eizaburo Matsubara, Kyoto. Mr. Matsubara is president of a large milk company. He has a vast collection of over 7,000 items of the miniature but characteristic Japanese arts such as netsuke, *inro,* writing brushes, seals, gourds, etc. He has built a small museum which he plans to use for display of his fine collections.

2

◆ HORSE

PL. 3. A superb carving by Kaigyokusai, one of the most famous of all netsuke artists. He is renowned as a perfectionist who demanded perfect material for his work. The raised mane, the fine regular hairlines, the elegance of the carving, and the beauty of the material are all clear in the illustration.

> Material: Ivory. The eyes are inlaid in tortoise shell and the
> pupils in black coral *(umimatsu)*.
> Length: 4 cm. (1 1/2″)
> Signed: Kaigyokusai
> Date: 19th century

From the collection of Mr. Michael A. Braun, an American lawyer practicing in Japan. Mr. Braun has a comprehensive collection of excellent quality, comprising more than 1,000 pieces.

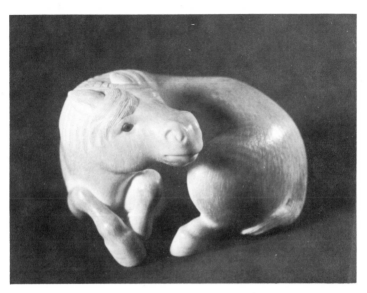

3

◆ CHICKEN

PL. 4. The animals of the zodiac are common subjects in netsuke, but the chicken is relatively rare, perhaps because of the difficulty of composing or rather compressing the design into the rounded form of a good netsuke.

> Material: Ivory
> Length: 4.3 cm. (1 7/10″)
> Signed: Okatomo
> Date: 18th century

Okatomo is one of the 54 netsuke carvers mentioned in the *Soken Kisho*. From this we know that he was early (18th century) and that he lived in Kyoto. Other biographical data are missing or scant. Okatomo is most famous for his carving of the quail standing on millet grains, a subject which he apparently carved over and over again. For this reason the subject is a signal for caution. The copier is prone to fake the artist's well-known subjects rather than to create original designs that call for artistic abilities.

From the collection of Zenshiro Horie, Nagoya. Mr. Horie is a fine old gentleman who owns and operates a large automotive factory with more energy than many men half his age. For many years following the war he had a constant flow of Americans to his home as guests. In his generosity he has given away enough netsuke as presents to make two or three respectable collections.

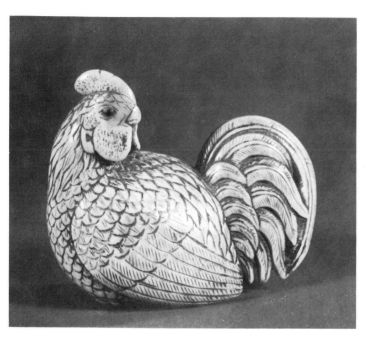

4

◈ SNAKE

Pl. 5.

> Material: Ivory, eyes inlaid in evanescent glass
> Length: 6.6 cm. (2 5/8″)
> Signed: Rantei
> Date: 19th century

Purchased from Spink and Son, London.

◈ NATURAL STONE

Pl. 6. A natural stone carefully selected for use as a netsuke. It is a good size and the hole through the stone permits easy attachment of a cord for suspending a hanging obiect.

> Height: 4.7 cm. (1 7/8″)
> Unsigned
> Date: Uncertain but early

From the collection of Shigeo Hazama, Kanazawa. Mr. Hazama is a successful real estate operator. He is one of the very few collectors in Western Japan, and has a small but excellent collection.

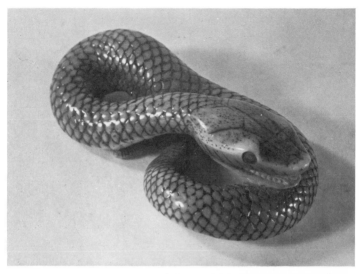

5

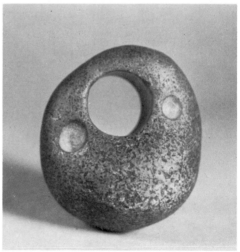

6

◆ THE FOUR CLASSES

PL. 7. The carpenter (artisan) with his marker and angle rule, the merchant with his abacus, the samurai with his swords and fan, and, with his back only showing in the illustration, the farmer with his pipe and hand plow—these four figures represent society in feudal Japan.

Material: Ivory
Height: 3 cm. (1 1/5")
Width: 3.9 cm. (1 3/5")
Signed: Issen
Date: Early or middle 19th century

From the collection of Michael A. Braun, Tokyo.

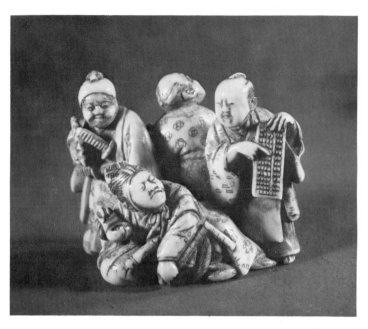

7

◈ INRO AND NETSUKE

PL. 8. An *inro* and netsuke in red lacquer *(tsuishu)* made by one artist in complementary designs. The slide bead *(ojime)* tightens or loosens the *inro*. Although the netsuke illustrated is a later example, it is the same type made by lacquer artists for the samurai class from the 16th century onwards.

> Material: Red lacquer *(tsuishu)*
> Length of netsuke: 4 cm. (1 7/16″)
> Unsigned
> Date: 19th century

Purchased from Tokuo Inami, Tokyo.

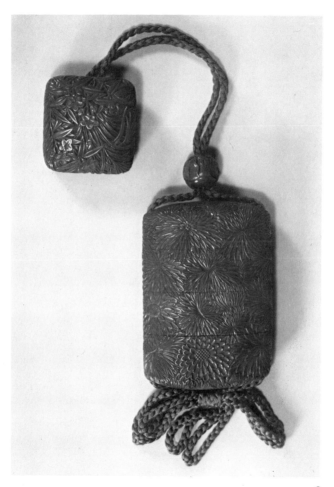

8

◆ NATURAL ROOT

PL. 9. A natural root carefully selected for its vague resemblance to a bird. A small amount of shaping and polishing improved the natural object.

> Height: 7.4 cm. (2 15/16″)
> Unsigned
> Date: 18th century

A gift from Takeshichi Yasutake, Kumamoto. Mr. Yasutake has one of the finest antique and curio shops in Kyushu.

◆ TIGER

PL. 10.

> Material: Boxwood
> Length: 3.7 cm. (1 3/8″)
> Signed: Kokei
> Date: 18th century

From the collection of Hiroshi Takama, Gifu, recently deceased. Mr. Takama's collection is now in the possession of his daughter, who also follows her father in his profession as pharmacist.

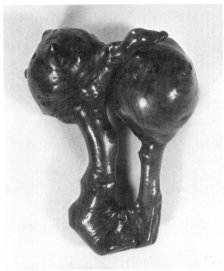

9

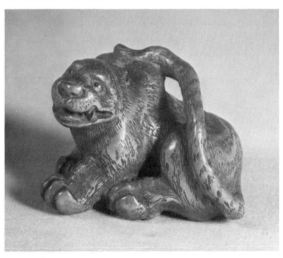

10

◆ CUTTING THE SAKE GOURD

PL. 11. The drunkard on "the morning after the night before" swears off drinking, and demonstrates the strength of his resolve by sawing his sake gourd into halves.

> Material: Wood, eyes inlaid in ivory and horn
> Length: Approx. 3.8 cm. (1 1/2″)
> Signed: Mitsushige
> Date: 19th century

From the collection of Edward A. Shay. Mr. Shay owns an engineering firm based in Los Angeles with operations throughout Asia. He is primarily a collector of fine gold lacquer *inro* but has incidentally acquired many interesting netsuke.

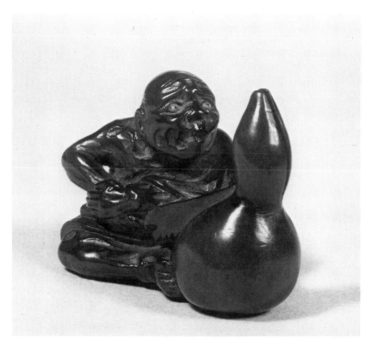

II

◆ RYUJIN, THE KING OF THE SEA

PL. 12. Ryujin holds in his hands the jewel that governs the tides. The dragon, his trusted assistant, rides on his back.

Material: Boxwood
Height: 7.9 cm. (3 1/8″)
Unsigned
Date: 18th century.

Purchased from Toraya Company, Tokyo.

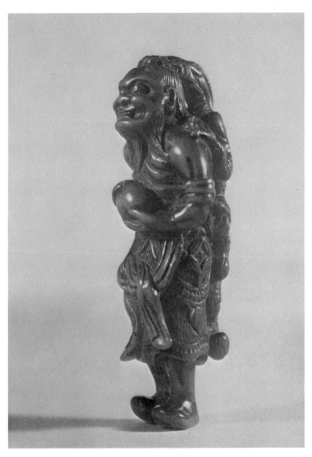

12

◆ CARP

PL. 13. A large bold primitive design. The fish meets one of the minor tests of a good netsuke by standing upright on its fins.

Material: Ebony
Length: 8.3 cm. (3 1/3″)
Signed: Kiyoshi (may also be read Sei). Written in seal
 character *(Tensho)*
Date: Probably early 18th century

Kiyoshi or Sei is not listed in *Ueda Reikichi* and I am not familiar with other netsuke bearing this signature. One wonders about the identity of artists who suddenly appear at the height of their power in one or two netsuke and then are never found again.

Illustrated as No. 191 in *The Netsuke Handbook of Ueda Reikichi*.

Purchased from Y. Otsuki, Kyoto Handicraft Center, Kyoto.

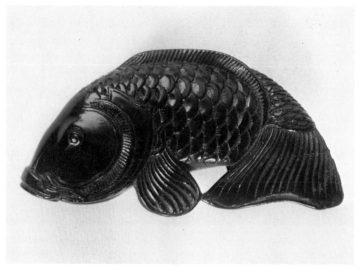

13

◈ SOUTH SEA ISLANDER

Pl. 14. A native of the South Sea Islands is holding a lobster. The artist emphasized the material, narwhal ivory, by leaving untouched an oval reserve which reveals the characteristic spiraling grooves of the bark. Garaku utilized the reserve to place his signature.

Material: Narwhal, eyes inlaid in black coral
Height: 7.2 cm. (2 7/8″)
Signed: Garaku
Date: 18th century

Purchased from Kazuo Itoh, Tokyo.

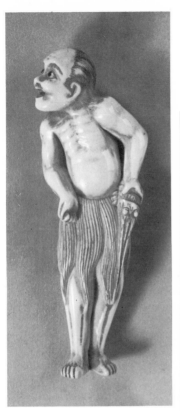

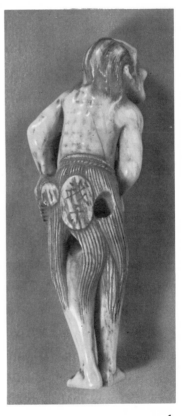

14-a

14-b

◆LONG ARM, SHORT ARM

PL. 15. This is an illustration of racial cooperation from Chinese legend. The long-armed people and the short-armed people lived on opposite sides of the river. They cooperated in the use of their physical assets to catch fish, as in the illustration.

Material: Staghorn
Height: 6.4 cm. (2 9/16″)
Unsigned
Date: 18th century

From the collection of Hazel H. Gorham, Tokyo. This is illustrated on page 13 of *Japanese Netsuke* by Hazel H. Gorham. Mrs. Gorham has also written books on Oriental pottery and flower arrangement. She is a long time resident of Japan, and has accumulated her netsuke collection through gifts from numerous Japanese friends. In the same way she is disposing of her collection to friends piece by piece.

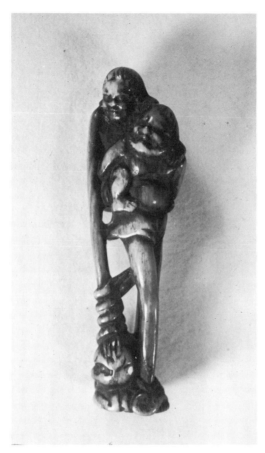

15

◆ MASK

PL. 16. The mask is in the two natural colors of hornbill (toucan) ivory. The hair is orange-red and is surmounted by a peony. The face is yellow. The mask represents the one used in the Lion Dance in both Noh and Kabuki. The dance is performed before flower beds of peonies.

> Material: Hornbill ivory
> Height: 4.2 cm. (1 5/8″)
> Unsigned
> Date: 19th century

Purchased from Kazuo Itoh, Tokyo.

◆ STYLIZED GOAT

PL. 17. On an oval base. The design indicates strong Chinese influence.

> Material: Rhinoceros horn
> Height: 5.6 cm. (2 1/4″)
> Unsigned
> Date: 17–18th century

From the collection of Alfred Smoular, Paris and Tokyo. Mr. Smoular is the Far East correspondent for *Les Echos*, Paris, and other publications. He has a fine collection of Oriental art, particularly Korean bronzes and celadons.

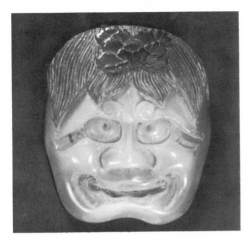

16

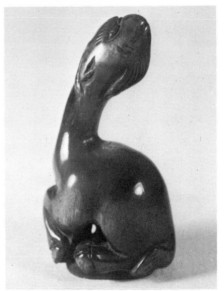

17

◆ KAGAMIBUTA

PL. 18. This is a particular type of netsuke consisting of a wood
or ivory bowl with a metal lid, the latter comprising the main
part of the design. Kagamibuta were usually made by metal
artists and swordsmiths.

The design illustrates the Japanese version of the werewolf
story. The woman is a normal wife by day, but under the light
of the moon she reverts to her feline form.

> Materials: *Shakudo*, *shibuichi*, copper, silver, and gold
> Diameter: 4.5 cm. (1 13/16")
> Unsigned
> Date: 19th century

Purchased from Kaji Shoten, Kyoto.

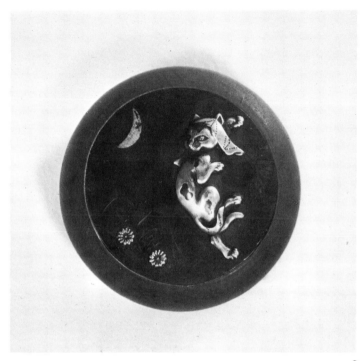

18

◆ IVORY NUT

PL. 19. Ivory nut, or vegetable ivory, was imported from South America. The face seems to be that of Fukusuke, the large-headed dwarf, who attained great popularity as a comic and storyteller.

Height: 4.3 cm. (1 7/10″)
Unsigned
Date: Late 19th century

From the collection of Murray Sprung. Mr. Sprung practices law in both New York and Japan. He collects many classes of Japanese art, including netsuke, *okimono*, and rare books.

◆ BUSHY-TAILED TURTLE

PL. 20. The turtle with the bushy tail derives from Chinese legend and signifies longevity.

Material: Wild boar tusk
Length: 7.3 cm. (2 7/8″)
Date: 18th century
Signed: Iwami no Kuni Denshinsai Kamman saku (made) and kakihan. Iwami no Kuni is the region now known as Shimane Prefecture. Denshinsai and Kamman are both art names *(go)*. However, the artist is better known as Kamman. A kakihan is a written or carved seal for individuality and identification.

Purchased from Kazuo Itoh, Tokyo.

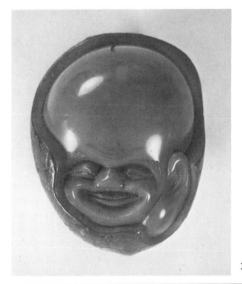

19

20

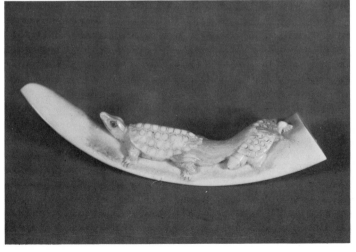

◆ OTAFUKU

PL. 21. She is the homely good-natured woman, the constant butt of jokes and jibes. At village festivals and holidays she is represented on stage by an actor who wears her mask. The play is usually hilarious and ribald.

> Material: Gold and colored lacquer. Face and feet inlaid in
> ivory
> Height: 4.3 cm. (1 3/4″)
> Unsigned
> Date: 19th century

From the collection of Dr. Anne Kaemmerer, who, with her late husband, formed several fine collections of Japanese art, especially prints and paintings. Mrs. Kaemmerer is a practicing psychiatrist in Tokyo.

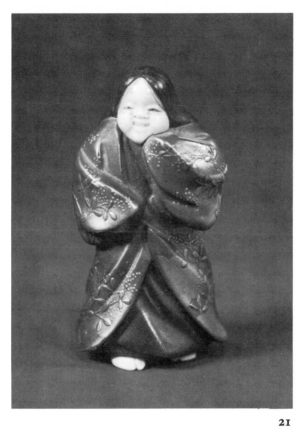

◆ BLOW FISH (fugu)

PL. 22. Though poisonous unless a certain sac is carefully re-
moved without puncture, the blowfish is a great delicacy in Japan.
There are restaurants that serve nothing but blowfish prepared in
several ways.

> Material: Boxwood
> Length: Approx. 5 cm. (2″)
> Signed: Hidari Issan. Hidari means left handed and is not
> part of the carver's name
> Date: 18th century

Purchased from Deto Koichi, Kyoto.

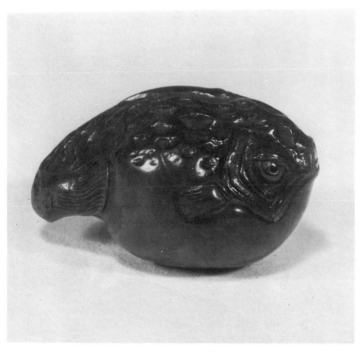

22

◆ PUPPY AND FLY

PL. 23. The puppy seems to be amused by the fly. This was carved by Ranichi, a 19th-century carver and a pupil of Rantei. Like his teacher, Ranichi was partial to animal subjects and generally carved in ivory.

Material: Ivory. Eyes in tortoise shell and *umimatsu*
Height: 2.7 cm. (1 1/16″)
Signed: Ranichi
Date: 19th century

Purchased from Akai Shiro, Nanmyō Shop, Nara.

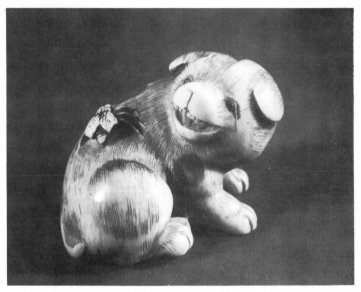

23

◖FOREIGNER WITH PORCUPINE

PL. 24. The subject is rare because the little animal carved on foreigner's shoulder is a porcupine. The porcupine—the Japanese call it a needle-rat—is known in Japan but for some reason is rarely portrayed in netsuke.

Material: Ivory
Height: Approx. 9 cm. (3 9/16″)
Unsigned
Date: Probably 18th century

Purchased from Kenzo Imai, Kyoto.

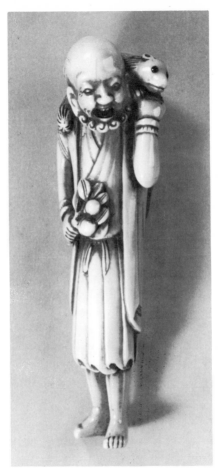

24

◆ CAMEL PAIR

PL. 25. The animals are actually the single-humped drom-
edary, a rare subject in netsuke. The netsuke is illustrated in
The Art of the Netsuke Carver of Frederick Meinertzhagen, from
whom the author acquired it.

Material: Boxwood
Length: 4.7 cm. (1 7/8″)
Unsigned
Date: Late 19th century

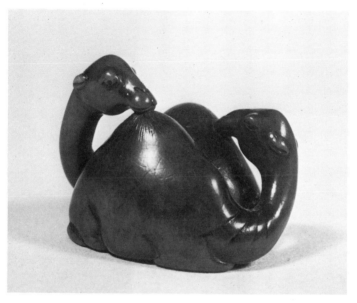

25

◈ MANJU NETSUKE

PL. 26. The *manju* is a particular type of netsuke, named because of its resemblance to the flat ricecake of Japan. The *manju* may be carved of a single block or of two equal fitted sections.

The subject is Adachigahara, the fearful mountain witch and cannibal who fed on the flesh and blood of beautiful young girls.

Material: Ivory
Diameter: 5.5 cm. (3 3/16″)
Signed: Shunkosai
Date: 19th century

Purchased from Kohachiro Yokoyama, Kyoto.

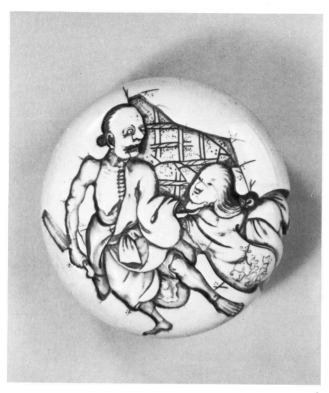

26

◆ FUKUSUKE

PL. 27. Fukusuke was a dwarf with an enormous head who was the sensation of his day during the Meiji period as an entertainer and storyteller. As represented in the netsuke his props include a club and rice server.

> Material: Wood
> Height: 6.8 cm. (2 3/4″)
> Carver: Tochinsai
> Date: 19th century

Purchased from Kazuo Kotera, Kyoto.

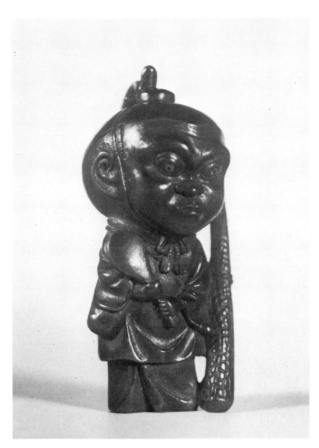

27

◆ AFTER THE BATH

PL. 28. In old Japan, particularly in rural communities, bathing *au naturel* in tubs outside the house was a common sight. In the illustration the farm wife arranges her hair after a refreshing bath.

Material: Ivory
Height: Approx. 5 cm. (2″)
Unsigned
Date: 19th century

From the collection of Michael A. Braun, Tokyo.

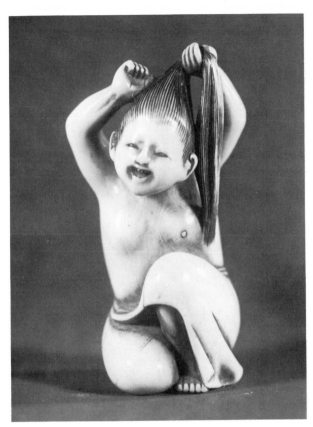

28

◈ FOX PRIEST

PL. 29. The figure wears a mask which cleverly combines the characteristics of man and beast. The main character of a familiar Noh play is represented, a fox disguised as a priest.

The carver is Morikawa Toen, who is famous as the foremost carver of Nara *ningyo* or dolls representing Noh actors, a typical souvenir of Nara. The style of carving is "single-knife cutting" *(ittobori),* which is characterized by flat angular planes something like hammered silver but with larger surfaces.

Material: Painted wood
Height: 8.8 cm. (3 1/2″)
Signed: Toen
Date: 19th century

Purchased from Shiro Akai, Nanmyō Shop, Nara.

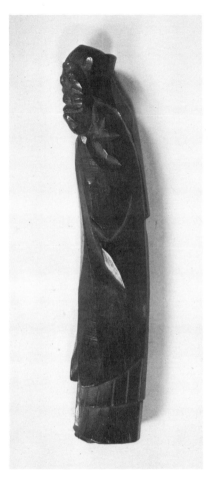

29

◆ MERMAID AND YOUNG

PL. 30. The mermaid, although a legend, has a basis in fact. Manatees or dugongs, sometimes called sea cows, are aquatic mammals related to the elephant. They have, of course, mammalian features and nurse their young. They feed on dense marine vegetation and are credited with keeping many shallow waterways of Southeast Asia from clogging.

> Material: Ivory
> Height: 3.9 cm. (1 1/2")
> Signed: Masotoshi.

Masotoshi is a contemporary artist who devotes himself exclusively to carving netsuke in accordance with traditional restrictions and techniques. He is remarkably versatile, prolific and original. Purchased from Y. Otsuki, Kyoto Handicraft Center, Kyoto.

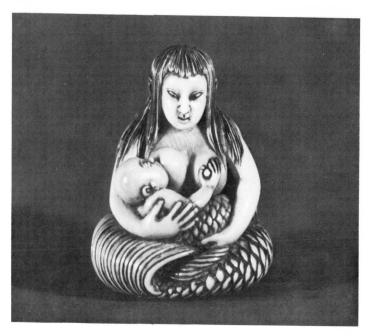

30